THE STORY IN A PICTURE

Children in Art

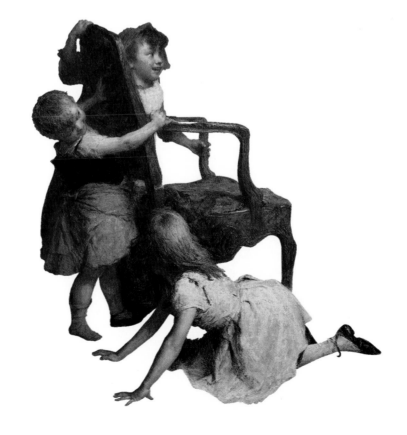

In loving memory of
Max Richmond Hampton

Front cover illustrations: **Picking Buttercups,** Minnie Jane Hardman. Courtesy of Priory Gallery, Bishops Cleeve, Cheltenham, Gloucestershire, England. **The Torn Hat,** Thomas Sully, 1820. Courtesy of Museum of Fine Arts, Boston; Gift of Belle Greene and Henry Copley Greene in memory of their mother, Mary Abby Greene. **Liberty Blake in a Kimono,** Peter Blake, 1971. Private Collection: © The Artist. Photograph: Alex Saunderson. **Princess Isabella de Medici,** Angelo Bronzino, 1542. Courtesy of Galleria degli Uffizi, Florence, Italy. Photograph: Index/P. Tosi. *Back cover illustration:* **Little Girl in a Blue Armchair,** Mary Cassatt, 1878, National Gallery of Art, Washington, DC: Collection of Mr. and Mrs. Paul Mellon. *Half-title page illustration:* **Blind Man's Buff** (detail) Alexander H. Burr, 1888; Courtesy of The FORBES Magazine Collection, New York. *Title page spread illustrations:* **Children's Games** (details) Pieter Bruegel, 1560; Courtesy of Kunsthistorisches Museum, Vienna.

Text copyright © 1992 by Robin Richmond
Illustrations copyright © 1992 by individual copyright holders

Published by Ideals Publishing Corporation
Nashville, Tennessee 37214

Printed and bound in Mexico.

Library of Congress Cataloging-in-Publication Data
Richmond, Robin.
The story in a picture: children in art/by Robin Richmond.
p. cm.
Includes index.
Summary: Presents a survey of art history and techniques through a series of paintings of children going about their lives. Includes information on the life and work of each artist.
ISBN 0-8249-8588-5 (lib. bdg.)—ISBN 0-8249-8552-4 (trade)
1. Children in art—Juvenile literature. 2. Painting—Juvenile literature. 3. Painters—Biography—Juvenile literature. [1. Children in art. 2. Painting—History. 3. Art appreciation.] I. Title.
ND1460.C48R53 1992 750'.1'1—dc20 92-7184 CIP AC

The display type is set in Garamond Swash.
The text type is set in Garamond.
Color separations made by Web Tech, Incorporated.

Created and designed by Treld Bicknell.

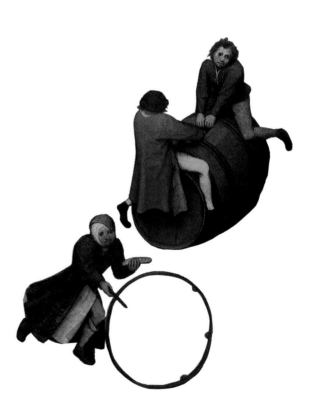

THE STORY IN A PICTURE

Children in Art

by
Robin Richmond

Ideals Children's Books • Nashville, Tennessee

CONTENTS

VI. OUTINGS

VII. THE WAY WE LOOK

VIII. PAINTING THE PICTURE

IX. THE PAINTINGS

INTRODUCTION

As you walk through an art museum or gallery, you often see that the paintings are arranged on the walls according to the date, or period, and the country in which each was painted. Sometimes there are even signs directing you to the next paintings in the series. This helps you to understand how painting has developed and changed throughout its long history. But it certainly isn't the only way to look at art.

If you think of this book as a miniature museum, you will see that I have organized it in a different way. For *my* museum I have picked out paintings that are all about the same subject. My museum is filled with paintings from all over the world, from China to Central America. Few museum directors are so lucky!

Many people—not just children—are puzzled by art. It seems so complicated, and it is hard to know where to start. Looking at one subject at a time makes it easier to understand what the artist is doing. I have chosen a theme for my museum that is very familiar to you— children—so you already know that you will be looking at people very much like yourselves. But are they? Or are children today different from children in the past?

The architecture and clothing in the paintings have changed over the centuries, but children seem to have always liked and disliked the same types of things. Artists, however, have thought about children in many different ways throughout art history because they have had many different reasons for painting children.

Some of the children in this book are dressed in silks and finery. These are formal portraits, and they make the children look like miniature adults. Often the artist is trying to flatter the family. This type of painting—the Sargent portrait of the Boit sisters, for example (page 24)— says more about the wealth of the parents than about the personalities of the children, but it is still a satisfying painting. You can imagine it hanging in an elegant room over a marble mantelpiece.

Some paintings show children just being themselves, in all their various moods, even bad ones. The Mary Cassatt painting of the little girl (page 30), who is probably her niece, shows the model's complete boredom with sitting still. The artist has recreated the atmosphere so successfully that you can almost *smell* the stuffiness of the over-furnished room.

Sir Walter Raleigh's son (page 29), on

the other hand, is quite happy posing with his father and doesn't look bored at all.

Knowing a little about the relationship between people in a painting or between the artist and his or her model can help you discover hidden meanings in a painting.

There may be some paintings in this book that look strange to you. A lot of modern painting tries to express the artist's *feelings*, rather than showing us how the world looks. But every picture has a story to be told, and I want to tell you these different stories.

Artists are not always very good at talking about their own work, or even about other people's work, because art is not about words, but about *looking*. It's hard to put into words what you feel when you look at a picture, and that is the most magical thing about art. A picture can make you feel happy and excited, or gloomy and sad—and there's no need to explain these feelings. Sometimes a picture is confusing or strange, but knowing something about the artist's life will help you to understand and appreciate the painting.

I am an artist. But I know that what happens in my life as wife, mother, sister, daughter, teacher, or friend also influences my work. When I am painting a picture, I don't pay much attention to what is going on outside the studio where I work. But I can often look back and say, "Oh yes, I painted all those funny pictures of trees because living in the city was driving me crazy!" or "I painted my children, Adam and Saskia, playing checkers because that was the Christmas that we found an old set in the attic."

This book begins with one of my own pictures. I will try to explain what made me paint the picture and how I painted it as honestly and clearly as I can. Together we will look at the work of some of the world's greatest artists and try to see what children meant to them in their work.

Look at the paintings in the book several times and think about them. Then when you get the chance to visit them in museums and galleries, it will be like visiting an old friend.

Robin Richmond

I. CHILDREN AT PLAY

Christmas at Le Chalard, 1991
ROBIN RICHMOND

I LIVE IN LONDON, WHICH IS BIG, NOISY, AND dirty. But I love the excitement of living in this city. If I lived in the peaceful countryside, I couldn't hop on a bus and within fifteen minutes be at one of the world's great art museums. *But* I do need peace and quiet for my work too.

Tucked into a forgotten corner of the French countryside is my hideaway. I have a studio there where the phone never rings and where I paint my best pictures. At Christmastime, my family packs up the car and we spend the holidays in France. For me, it is the best of both worlds.

For this picture, painted especially for this book, I sat in my living room and painted the scene exactly as I saw it. The story it tells is simple and clear—it is a record of a happy family Christmas. I wanted to put the love that I feel for my children into the painting, but I did make them very impatient while I painted it!

My easel was in their way, my oil paints cancelled out the lovely smell of the Christmas tree, and they got bored with checkers long before I had finished. In the end, however, everyone was pleased to have this happy time recorded by the painting, and they forgave me.

Like Matisse, I love patterns, and my own painting reflects my admiration for this great artist. The focus of both his family painting and mine is the pattern of the checkerboard. My French room, like his, is ablaze with competing patterns— from the Moroccan carpet on the floor to the chintz sofa with its comfortable old picnic blanket folded over the arm.

Over the holidays, my daughter, Saskia, and I read E. Nesbit's *The Phoenix and the Carpet* and pretended that our carpet was magical—it even seems to float in the painting. And the shadows cast by the glowing embers of our friendly wood-burning stove certainly added to our fantasies.

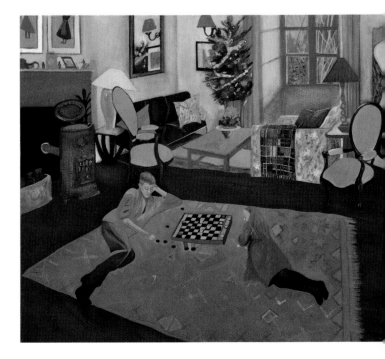

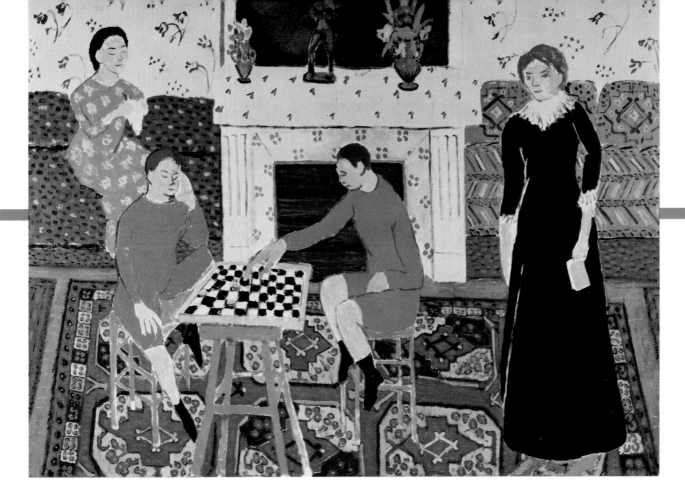

The Artist's Family, 1911
HENRI MATISSE

"What I dream of is an art of balance, of purity and serenity devoid of troubling or depressing subject matter . . . something like a good armchair which provides relaxation from physical fatigue."

(from *Notes of a Painter,* Matisse, 1908)

I THINK THE FEELINGS MATISSE HAD FOR HIS family must have been similar to my own, judging from this picture. He loved the comforts of family life, although not many artists would dare to say that they think art should be like an old armchair. But why shouldn't painting be comfortable sometimes?

What most people don't realize when looking at the work of Matisse is that he makes art look *easy,* like watching an expert trapeze artist sail through the air under the big top. But his great skill is in making *seem* easy what most definitely is not. Matisse puts many patterns into this painting, but instead of fighting with each other, they fit together like pieces of a puzzle.

He really could use color like no one else, and even when his colors are somber, as in *The Piano Lesson* (page 15), it is for a reason. His color range, or *palette*, gives clues about the story in the picture that he wants to tell. While *The Artist's Family* is about pleasure and warmth, *The Piano Lesson* is about discipline and effort, as you will see. As an artist, I am very influenced by the way Matisse uses color to convey different moods. And I like the way he uses so many different patterns too.

Matisse's drawing, which appears

carefree, is actually quite carefully planned—the lines he draws are very definite in where they are going. It's as though painting is a language, and Matisse speaks, and even sings, it fluently.

Matisse's pictures are joyful. Even when he was old and confined to bed due to illness, he never stopped believing in the happiness of life—what is called *bonheur de vivre* in French. He bravely drew, with a long stick, brilliantly colored shapes on paper glued to the ceiling of his room. His assistant would then take them down, and Matisse would cut out the shapes with scissors. When you make cut-outs at school, you are working in a famous tradition of French art.

His studio and home were decorated differently from the "modern" tastes of his friends. Matisse worked in a room filled with rugs, pictures, cushions, flowers, plants, oriental pictures, and—most importantly—light.

Seeing his sons playing checkers on the black and white board must have inspired this picture, which could easily be entitled *Family Happiness*. His wife, Amelie, sits embroidering while his sons, Pierre and Jean, play their game. His daughter, Marguerite, reads her bright yellow book. This is a real family room—warm, comfortable, and welcoming, much like "a good armchair."

Children's Games, 1560
PIETER BRUEGEL

WATCHING CHILDREN PLAY HAS always fascinated painters. Matisse painted his own children at play, and there is an intimacy in his work. Bruegel is not concerned with intimacy. He seeks the endless movement and shifting colors of large groups of people living their daily lives. His pictures are full of tiny figures doing very real, day-to-day things.

If you have ever seen a movie being made, you will know that sometimes the camera is placed on a tall crane, a machine that can swoop the camera from high up in the air right down to ground level. When Pieter Bruegel painted this picture, no one had even dreamed of movies, yet he seems to have had a director's, or even a bird's-eye, view of this small, 16th-century Dutch town. It must have come to him in his dreams, for where in reality could he have seen a town populated only by children, looking like a summer camp gone wild?

Most of Bruegel's surviving paintings—there are only fifty—are of village life. Unlike many other artists of his time, Bruegel did not paint for princes, for churches, or for wealthy businessmen. Nicknamed the "Peasant Bruegel," he painted ordinary people and their daily life activities: eating, hunting, skating, and even fighting. All of his paintings are packed full of details and incidents that tell a story.

Most painters have a very good idea of how your eye will move, and they

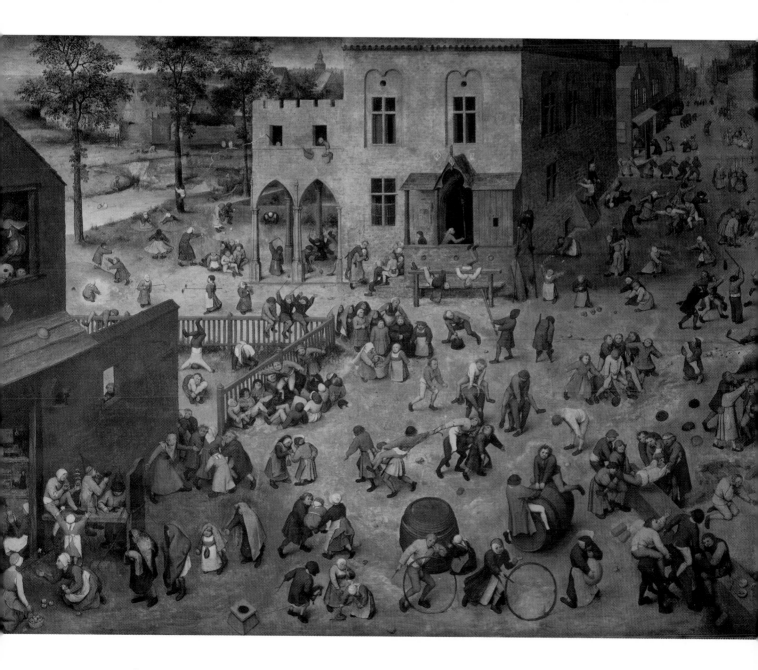

construct their pictures to lead you from the front of the picture, called the foreground, to the background. In this way, they encourage you to "eat up" the whole picture with your eyes, leaving nothing behind. Bruegel does so by making the buildings and children grow smaller and smaller as they get farther away. The lines in the painting lead your eye down the street, out the back, and into infinity.

What games are the children playing? Even though this picture is over 400 years old, you may recognize many games, because children today play these same games the world over. Perhaps you can count the games you see. I see leapfrog, rolling a hoop, juggling, blind man's buff, see-sawing, model-making, cards, tug-of-war, bricks, dancing, singing, somersaulting, acrobatics, tree-climbing, bowling, ring-around-the-rosy, hockey, stilt-walking, balancing, wrestling, blowing balloons, hobby-horse riding, fighting, gymnastics, painting, and many more.

Blind Man's Buff, 1888
ALEXANDER H. BURR

THIS GAME IS STILL PLAYED BY CHILDREN all over the world, although it is known by different names in different places. Children are even playing it in the Bruegel painting (page 11). Many people call the game "blind man's bluff" in English, but the real name is "buff"—referring to the buffeting that the blindfolded player gets when he or she knocks into things.

This picture was painted in London and exhibited at the famous Royal Academy during the reign of Queen Victoria. The Victorians were very fond of idealized

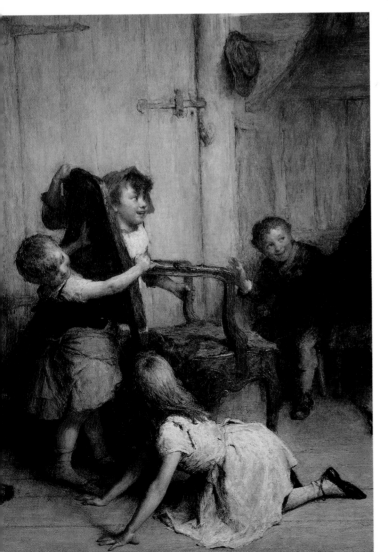

pictures of children and were sentimental about what they saw as the innocent, carefree days of childhood. They may have felt this way because they knew that reality was often very different, and many children died from diseases which had no cure until this century. There was terrible poverty in those days, especially in the cities, and young children were often sent to work in both mines and mills.

But children were also loved and cherished, and the more fortunate ones—like those in the painting—were able to enjoy childhood in comfortable homes.

The old saying that "Children should be seen and not heard" has been turned on its head in this painting—for the children are playing the game with a grown-up (perhaps he is their good-humored grandfather) and have blindfolded him so that he can hear them, but they can't be seen at all. The game is wild and chairs and toys are scattered, but everyone seems to be enjoying the scene—including the artist.

II. MUSIC AND DANCING

The Hundred Children (detail)
CHINESE, MING DYNASTY

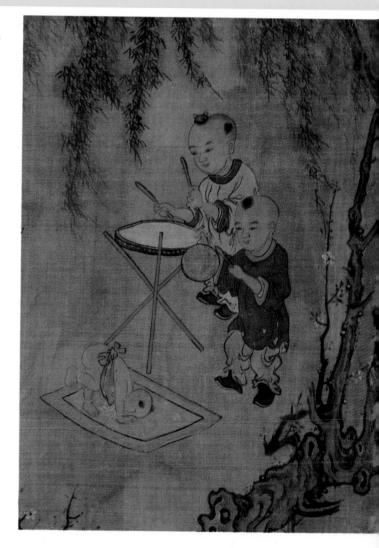

GIVING BIRTH TO BOYS WAS CONSIDERED particularly lucky in Chinese families, and the unknown painter of this scroll—a painting done on a very long piece of parchment or paper—was probably celebrating the good fortune of the wealthy family who commissioned the artwork. Very little is known about the scroll itself, but the "hundred children" are shown in different parts of the painting, playing games and making music together. I love the little baby trying to turn a somersault on the green mat—he wants to play too!

The games played by these children in 17th-century China might be familiar to the children in Pieter Bruegel's Dutch town (page 11) and to children in playgrounds all over the world today.

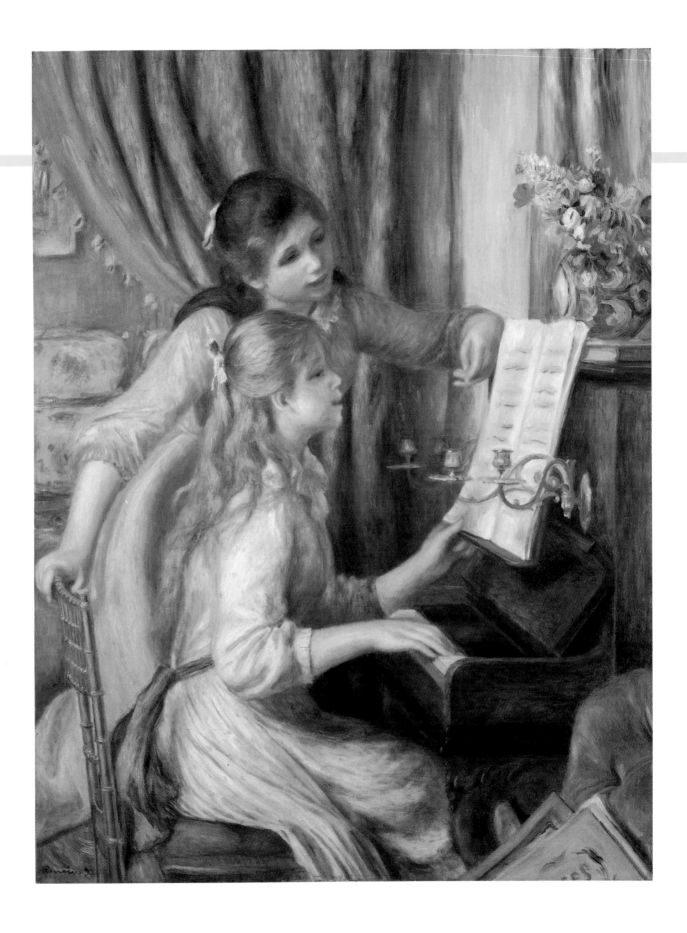

Young Girls at the Piano, 1892
PIERRE AUGUSTE RENOIR

RENOIR TRAINED AS A PAINTER OF porcelain as a young man. He was expert at decorating the delicate china ornaments that were fired in the factories of Limoges chinaware in southwest France.

He met Claude Monet in Paris in 1861, and they—like Bruegel (page 11)—decided to paint everyday life as they saw it. Renoir painted outdoor life in cafés and parks and nightlife in theaters and bars. He also painted the day-to-day life of average Parisians at work and at play. In 1870, this new form of painting was dubbed "Impressionism," because it captured the "impression of a moment in life."

The two young ladies in this painting are from a comfortable home. Look at the polished piano, the vase of flowers, and the glimpse of a luxurious sofa in the room beyond the green velvet curtains. They also seem to be enjoying the music—their expressions are a bit dreamy.

The Piano Lesson, 1916
HENRI MATISSE

COMPARE THIS PICTURE WITH THE RENOIR (opposite). Anyone who has ever had to practice the piano and *didn't* enjoy it can immediately relate to the tension in this painting. The boy has a metronome, a machine for measuring time on the piano, practically embedded in his forehead. This abstract triangular shape shows us the feeling of fatigue and a sense of boredom. The shape of the actual metronome is repeated on the red piano and in the slice of green garden on the left side of the picture. On the right is a stiff stick-figure sitting on a stool, probably the boy's piano teacher. How severe she looks! And the height of the stool makes her appear very prim.

Matisse liked to experiment in his art, and he is most loved for his wild, exuberant use of color, as in the picture on page 9. But in this painting, there is more gray than any other color. I think Matisse was trying to communicate feelings of boredom and hardness with the jagged shapes, while Renoir's painting is all softness and gentle curves. Two very different painters. Two very different pianists!

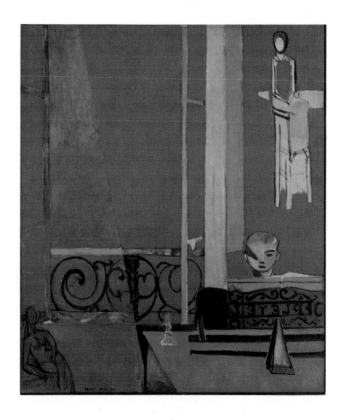

Breton Girls Dancing, Pont Aven, 1888

PAUL GAUGUIN

NOT MANY PEOPLE WOULD GIVE UP A successful career in business to become an artist, but Paul Gauguin gave up his job as a stockbroker, left his wife and children, and made his way to Brittany, on the northwest coat of France. Later, his love for all things exotic and foreign took him to the South Pacific, where he remained until he died.

Gauguin settled in Pont-Aven, Brittany, in 1886, where he painted what he saw around him. He loved costume and was obviously interested in the local dress worn by the Breton people. He loved the starched headdresses, wooden clogs, and the long, dark dresses worn by the women and even the little girls. The Breton people have a very special culture, and even today they honor many of the old customs and wear these costumes in remote parts of this wild coastline. Here the girls are performing a variation on the game of ring-around-the-rosy, and they are wearing their "posies" on their bodices in the form of red carnations.

Gauguin yearned for the freedom of more unspoiled people and places and found it in Tahiti in 1891. Here the women wore brightly colored fabrics draped around their bodies. Gauguin loved their freedom and rejected what he

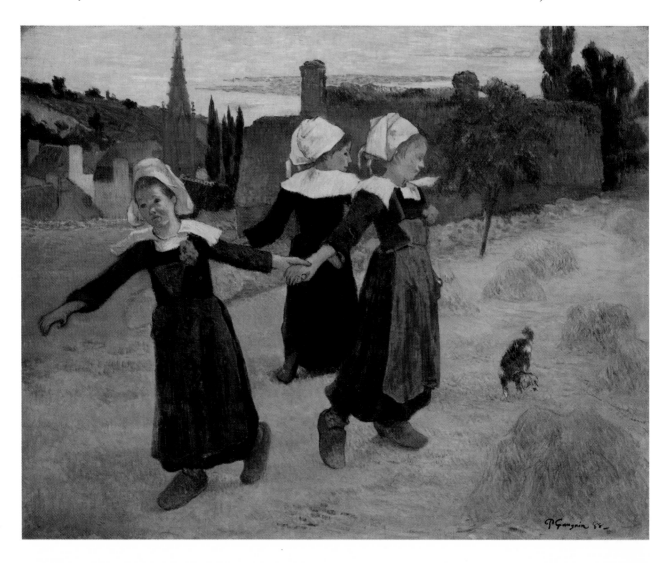

considered to be the dull, stuffy life in France. He thought that it would be good for his art to live away from France, and indeed his interest in color did ripen in Tahiti. But you can see in this picture of Pont-Aven that his interest in color began to blossom like the girls' posies long before his journey to the South Pacific.

Dance of the Mourning Child, 1922

PAUL KLEE

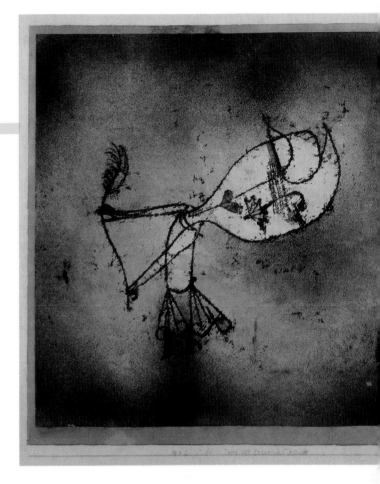

PAUL KLEE PLAYED THE VIOLIN VERY WELL and loved music nearly as much as painting. You can almost feel the rhythms of sound and dance in his strange, poetic pictures, many of which are filled with squiggles and swirls of color that seem never to stay still. In addition to being an artist, Paul Klee was a teacher. He knew how to talk about art, wrote many books about the subject, and gave lectures too.

As a young child, Klee drew constantly, and as a grown-up, he said drawing was like "taking a line for a walk." I think this is one of the most wonderful things anyone has ever said about drawing, and I also think he is absolutely right.

This beautiful, sad picture is full of funny things. The title makes us think of a child in mourning, or feeling pain for something or someone who is lost. But if we look carefully, we can see bits of humor in Klee's work. The child has a pink umbrella upside-down on her cheek and a most appealing heart-shaped mouth,

which looks ready for a kiss. She holds a peacock feather, an old symbol for loss in art history, but she dances in empty space with such happiness that nothing seems very wrong at all. You can almost feel her swaying to some off-stage music.

One of the things I like best about Paul Klee is his sense of humor. He always saw the absurdities in life and painted them with a light-hearted affection. And he must have liked this picture because he copied it twice.

III. LEARNING

The Young Governess, c.1739
JEAN-BAPTISTE SIMEON CHARDIN

IN BOTH OF THESE PAINTINGS, WE SEE children learning from a teacher, but the atmosphere of the lessons couldn't be more different. In Chardin's picture, the little girl is just learning to read, and she probably doesn't take learning very seriously yet. Her chubby cheeks make her look innocent and playful. The teacher looks hardly old enough to be in front of the classroom, but we can see from her dress and hair style that she is about sixteen.

The little girl and her young teacher are completely involved in the lesson, and the picture is a realistic, domestic study of friendship. The schoolmistress is clearly fond of her pupil, as you can see in the indulgent, loving expression in her eyes. Perhaps she is a big sister or a very young governess living with the family. Her mouth is pursed, as though she is speaking, and the picture captures a distinct moment in the lives of real people.

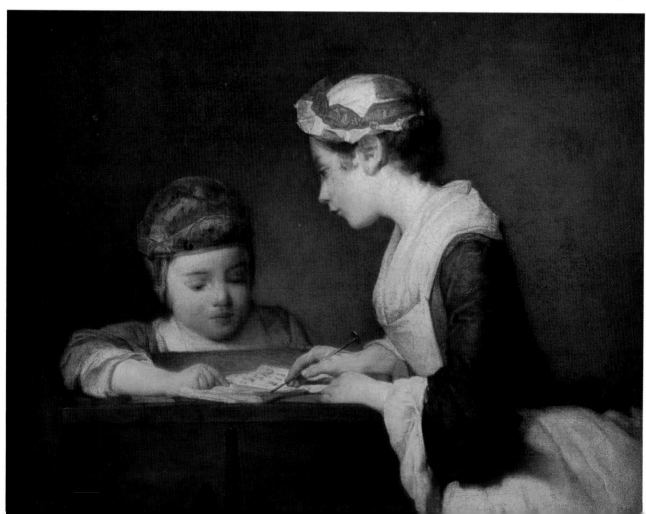

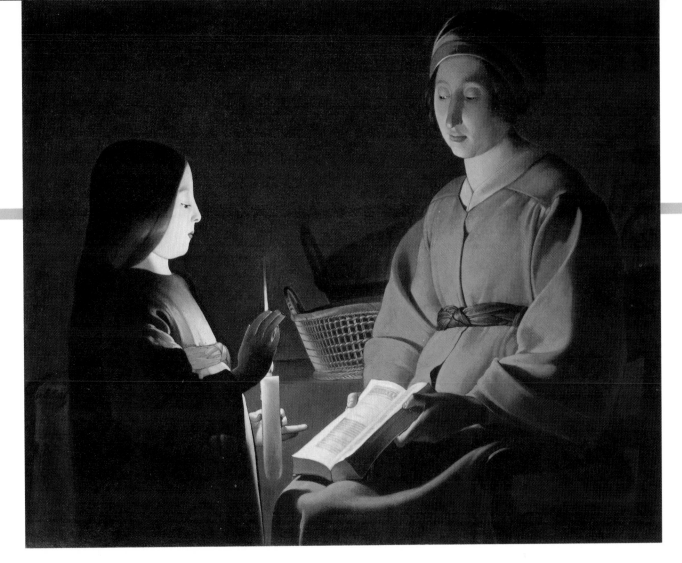

The Education of the Virgin, 17th Century

GEORGES DE LA TOUR

T HIS DE LA TOUR PAINTING TELLS QUITE another story. This work is full of drama and darkness. De la Tour is famous for painting scenes that are lit only by candlelight. His use of candlelight in most of his work gives the figures well-defined shapes and creates mystery. Unlike Chardin, this painting is a little creepy. The shadows lurking in the corners make us a bit edgy.

This is a picture of the Virgin Mary and her mother. We are used to seeing paintings of Mary as a grown-up and as the mother of Jesus (pages 22-23), but it is interesting to think of her as a child of eight or nine learning her lessons. If we picture her in different clothes, she even looks like she could be in school today.

Her strong face is very modern looking. And we can see the glow of the blood in her fingers as the light of the candle shines through her hand. She gazes down on the book with great concentration. De la Tour wants us to consider something important and surprising, and his picture reminds us that Mary was a child once too. In fact, here her childhood seems to have been too busy for daytime lessons. Laundry baskets lie waiting and unattended in the deep shadows of the nighttime kitchen.

IV. MOTHER AND CHILD

The Cradle, 1872

BERTHE MORISOT

ERTHE MORISOT WAS ONE OF ONLY TWO professional women artists in the Impressionist circle. Mary Cassatt was the other (page 30). Morisot's work is very different in feeling from that of her male colleagues, and I think you can tell by looking at her pictures that they were painted by a woman.

Her paintings—especially of mothers and children —are very quiet. The wild splashes of color in the Monet (opposite)

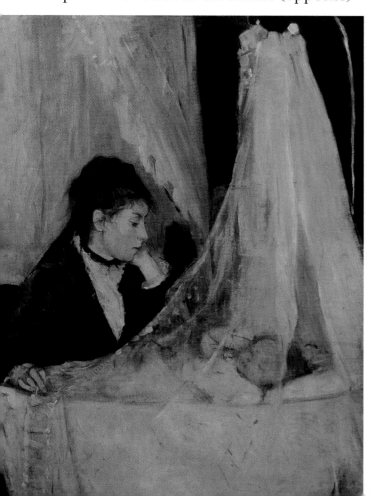

are muted by Morisot's rather somber tones of white and black. But the picture feels very real when you look at it. You can almost hear the silence. Maybe a clock is ticking. Maybe the woman is singing quietly. We are coaxed right into the peaceful atmosphere of the family home. We can almost hear the quiet breathing of the sleeping infant.

Our eyes are drawn into the protective circle of the young mother's fine hands. We know the baby is dearly loved from the warmth of the mother's face and her rapt look of attention. Nothing in the world will disturb this baby's peace. The fine white net of muslin sees to that and makes a pleasing contrast to the black velvet ribbon around the young mother's neck and her silken gown. The picture itself is like a lullaby.

The model for the painting was the artist's sister, Edma. Because Morisot painted people that she knew and clearly loved, her feelings of tenderness are communicated to us without any embarrassment. Through the artist, we can spy on a moment of intimate family life.

Camille Monet and a Child in the Artist's Garden in Argenteuil, 1875

CLAUDE MONET

CLAUDE MONET DEVELOPED THE STYLE OF painting called "Impressionism" (page 14), and this picture is a lovely example. Monet lived well into the 20th century, but he wasn't really a 20th-century man.

He wasn't particularly interested in man-made wonders, but he was devoted to the natural world. He loved to paint out-of-doors. He was excited by the color and the liveliness of flowers, trees, and water. He loved nature, and painting nature, so much that he spent forty years creating a water garden just so he could paint it.

Monet wanted to capture his first impression of a scene in his painting—the way a scene appears to our eyes in the first flash of looking at something. He painted many of his favorite scenes over and over again to catch the changes of light and shade in different seasons and at different times of day. This may sound easy but it's not!

What looks quick and light in a Monet painting, like the red flowers in this painting, probably took a week or two to paint.

The lady in the picture is his wife, Camille. In 1875, when he painted this picture, Camille was ill and the family had serious money problems. They were living in Argenteuil, on the Seine River near Paris, and had an eight-year-old son, Jean. The Monets were very friendly with another family, the Hoschedés.

Only five years after this picture was painted, poor Camille died and Claude Monet was left to care for Jean and their new son, Michel. Alice Hoschedé took on the whole Monet family and brought the boys up with her own six children. Monet married Alice in 1892, a year after her husband's death, and this happy marriage lasted until Alice's death in 1911.

The child in this picture must be the youngest Hoschedé, since the Monets had no daughters, but it's obvious that both Monet and Camille like the baby girl.

Monet loved poppies and they are almost the most important thing in the picture. Their exuberant energy makes a wonderful contrast between wild nature and the calm, quiet life of Camille and her sewing. Monet preferred painting landscapes and gardens to painting people, but his love for his wife radiates from this picture.

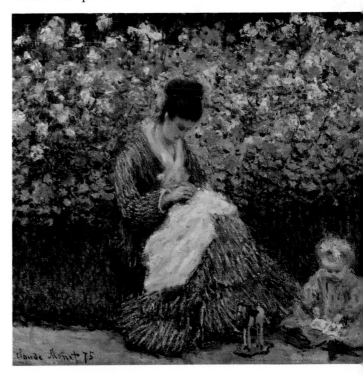

The Madonna of the Meadow, c. 1501

GIOVANNI BELLINI

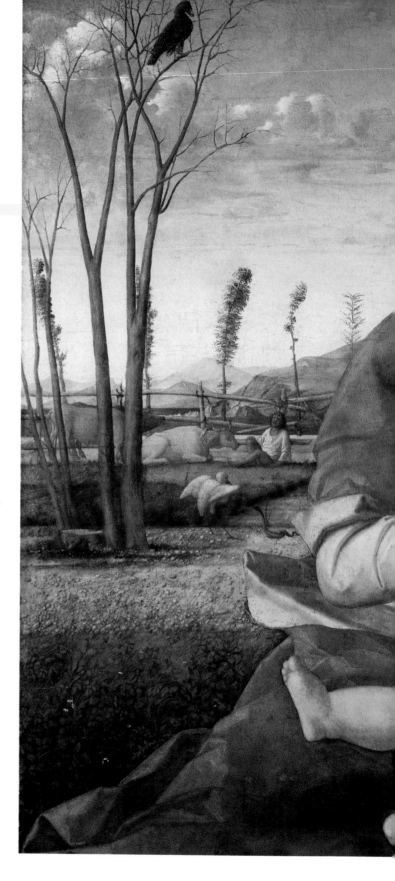

GIOVANNI BELLINI IS MY VERY FAVORITE Venetian painter. If I were stranded on a desert island, I would be certain to have a postcard of this painting in my luggage.

There were three painters in the Bellini family: the father Iacopo, and his two sons, Gentile and Giovanni. There were no art schools or academies in those long-ago days, so the sons learned about painting from their father. In their family workshop, or *bottega,* they worked on projects for the Church and for the government of Venice. In 1497, Giovanni was appointed Chief Painter to the State of Venice, a rare honor which he held until his death.

The Madonna and child—the infant Jesus—has become the most important "mother and child" image in art, and Giovanni Bellini is one of the greatest of those who painted this subject. The scene celebrates a joyous occasion and rarely hints at the sadness that the future holds for the family.

In Bellini's picture, Mary is delighted with her new son, and he lies, chubby and healthy, upon her blue cloak. Her hands are clasped in worship, or perhaps she is giving thanks for the safe delivery of her child. He lies calmly basking in the sunshine, blissfully unaware of the ox plowing the field and his own future.

And yet there is a bird of prey in the background by Mary's elbow. This is a subtle reference to death. On the left side of the picture, you also see a big, menacing blackbird in the barren tree.

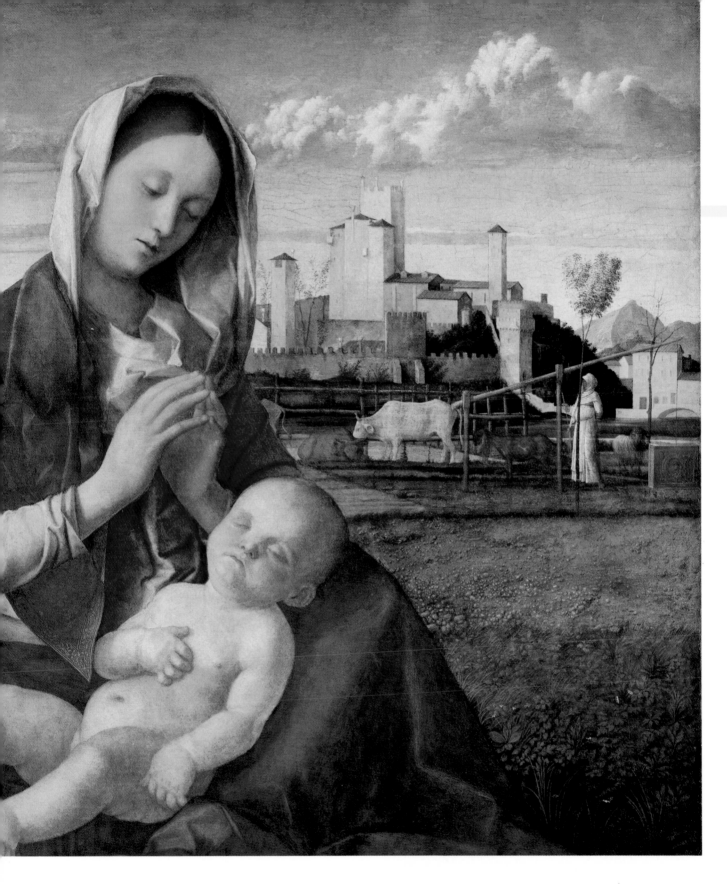

There is peace and tranquility in this picture, but it also shows signs of pain to come. An artist with the ability to capture two such opposite feelings within a single painting is truly a great master.

V. FAMILIES: FORMAL AND INFORMAL

The Daughters of Edward D. Boit, 1882

JOHN SINGER SARGENT

JOHN SINGER SARGENT EARNED HIS LIVING painting portraits of the well-to-do in Europe and America. This picture was painted when he was only twenty-six, in the Boit family home in Paris. It is a portrait of Mary Louisa, Florence, Jane, and Julia Boit—the daughters of another successful American painter.

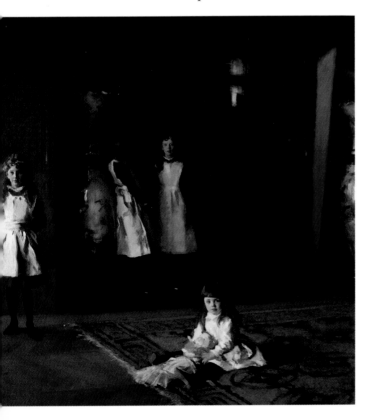

At first glance, it seems like a gentle picture of four pretty little girls—"The happy play world of a family of charming children . . ." as the writer Henry James described it. But that is just what it is not—the children are *not* playing or enjoying themselves at all. And the picture seems full of mystery. There is a curious light which makes little Julia, seated with her doll, the center of interest, while her elder sisters are almost in shadow. The room beyond beckons the eye into its cavernous, secret gloom.

The girls are perfectly well-behaved in their spotless white pinafores. Compare their careful poses with the happy chaos of *Blind Man's Buff* (page 12) and you will see that this painting is more concerned with the social status of the Boit family than it is with the children's "happy play world."

It is hard to imagine a rousing game of tag in this wonderful, large room or those Chinese vases crashing to the floor. But the girls must have been as well-behaved as they look, for I am told that those same vases are among the Boit family treasures and are still in perfect condition over a hundred years later.

Portrait of Miss Cicely Alexander: Harmony in Grey and Green, 1872

JAMES ABBOT McNEIL WHISTLER

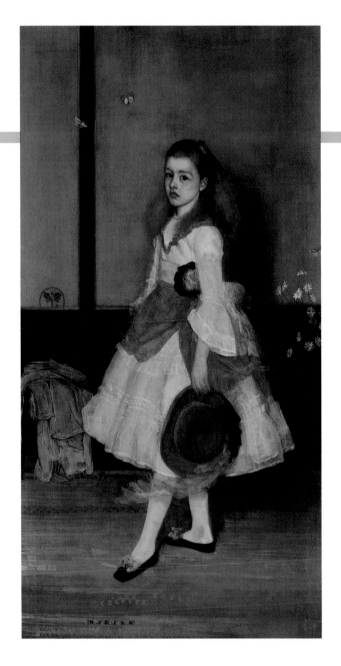

THIS, TOO, IS A COMMISSIONED PORTRAIT, like the Sargent painting (opposite). Poor young Cicely Alexander had to pose for the famous Mr. Whistler seventy times for this picture! How uncomfortable it must have been to stand still for so long in such a frock.

She looks so elegant that she might be off to a tea party at the White House or Buckingham Palace. Her satin pumps, gauzy party dress, and velvet hat make her look very pretty. There is very little color in the picture; only the pink flush of her mouth and the faintest blush on her cheeks catch our eye. The background, too, is very simple.

James Whistler loved music and often titled his paintings with musical terms, such as nocturne, caprice, harmony, and symphony. Here he sets up harmony between the child and her surroundings. It's an artificial, theatrical setting, but it works. This formal portrait shows Miss Alexander not as a child, but as a member of an important family.

James Whistler was by no means an ordinary portrait painter. He was one of the most celebrated artists of his time. The Alexanders would have paid dearly for the privilege of having this famous American paint their dainty daughter. Whistler was very witty and clever, and he was popular at the dinner tables of Paris and London. He was so much of a social butterfly that he signed his pictures with this trademark. If you look carefully, you can find three butterflies in this painting.

Arthur, 1st Baron Capel, and His Family, 1640

CORNELIUS JOHNSON

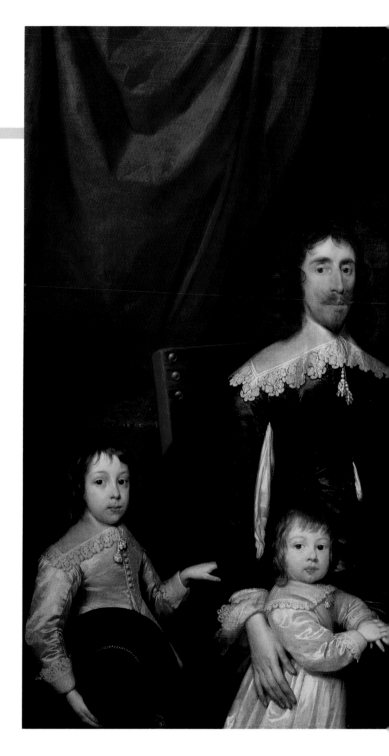

THE IMPORTANT ROYALIST CAPEL FAMILY commissioned this portrait as a family record, just as we might take a photograph today. They were to undergo terrible tragedy in the years that followed, because Baron Capel, the elegant man posing here with his wife and five young children, was on the losing side in the English Civil War (1642-48). He was executed in 1649, the same year his beloved king, Charles I, was sentenced to death for treason.

The war began because English people could not agree on which source had supreme authority: the king or the parliament. The great families of England took sides, either as Cavaliers, supporters of the king, or Parliamentarians, supporters of the parliament. Baron Capel was a devoted Cavalier, and he was killed the year after the Parliamentarians began an eleven-year reign under their leader, Oliver Cromwell.

The Capel children—pictured here in their family's early days of glory—are seen not merely as the dutiful offspring of loving parents, but as representatives of their time and social position; they represent future status and political power. After suffering through the war and its aftermath, the Capels regained their status, as well as their fortunes, when Charles II was restored to the throne in 1660. The

children went on to positions of influence: Mary (far right) became the Duchess of Beaufort, and Elizabeth (right) came to be the Countess of Carnarvon. Baby Henry, sitting on his mother's knee, was later Lord Capel of Tewkesbury, and his eldest brother, Arthur, (far left), was made Earl of Essex by Charles II.

The Artist's Wife and Children
HANS HOLBEIN THE YOUNGER

LIKE MANY PAINTERS OF THE PAST, HOLBEIN was trained by his artist father. At the age of seventeen, he began a lifetime of traveling and found his way to the royal court of King Henry VIII, where he made his name as a portrait painter. This king is famous for marrying six times in his search for a wife who could bear a healthy son. When Henry was looking for a new wife, he would send Holbein off to the royal courts of Europe to paint eligible, new brides. There were no convenient photographs in those days.

Holbein was an excellent portrait painter who captured the personality of his sitter, or model, in the painting. But sometimes his portrait was more beautiful than the living person. Henry fell in love with Holbein's portrait of Anne of Cleves and married her. But he was disappointed with the real woman and divorced her soon after.

When working for himself and not a demanding and imperious king, Holbein didn't need to be as flattering to his subjects. This picture of his family is very honest, almost brutal. It is also very dark and gloomy, unlike the portrait of the Raleighs (opposite). His poor wife looks exhausted, with bags under her eyes and a downtrodden expression on her face. The baby is not cute, but looks wizened and droopy, edging his way off his mother's lap. His older brother looks as if he would love to escape his mother's restraining hand and run out to play in the sunshine.

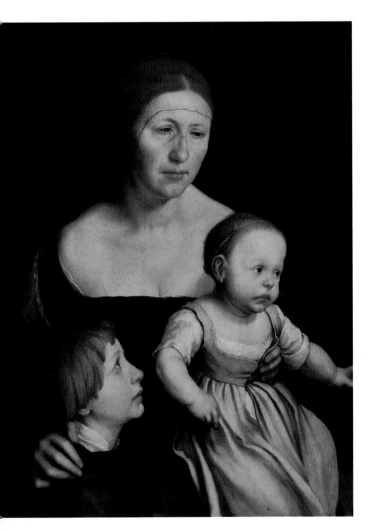

Sir Walter Raleigh with His Eldest Son, Walter, 1602
ARTIST UNKNOWN

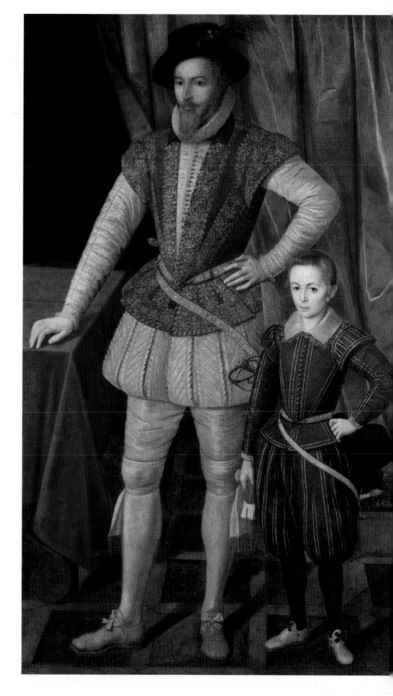

SIR WALTER RALEIGH WAS ONE OF QUEEN Elizabeth I's favorite courtiers. To honor her friendship with this brave adventurer, she made him a Knight of the Realm in 1584. In that year, he made the first of three expeditions across the Atlantic to America. Raleigh's difficult journeys to the New World introduced such things as the potato and the tobacco leaf to Europe.

At the height of his fame, Raleigh posed for an unknown court painter with his son Walter. Mimicking his father's heroic posture and proud look of success, the boy's expression is serious, his hand resting on his hip. He seems to enjoy being with his famous father and is conscious that his duty will be to follow in his father's footsteps one day. Young Walter will grow up to inherit the responsibilities of an important—but later disgraced—figure of the Elizabethan Age. But here he is in his youth, wearing the tight, stiff silks and satins of Elizabethan court dress, complete with a broad-brimmed hat and ceremonial sword.

Little Girl in a Blue Armchair, 1879

MARY CASSATT

MARY CASSATT WAS AN EXTREMELY well-bred young woman. Her home was near Philadelphia, Pennsylvania, which she left for the very improper city of Paris. Her father, a banker of conventional views, did not approve, but she was a very determined girl. Cassatt wanted to be an artist, and Paris was the place to learn.

She settled there at the age of twenty-four and became friends with most of the important artists of the day. She lived for her work and never married, although she did share a close friendship with Edgar Degas. She adored her nieces and nephews and painted them often.

The little girl in this picture looks extremely bored, caught unposed in an unguarded moment, similar to the Peter Blake painting (page 44). This painting is more like a photograph than the formal portraits of the Misses Boit and Alexander (pages 24 and 25). The child reminds me of the heroine of Kay Thompson's children's book, *Eloise,* who lived at the famous Plaza Hotel.

Mary Cassatt's model sprawls in her overstuffed armchair with her skirt riding up on her plump legs. She looks overstuffed herself, as if she has just finished a big meal. You can imagine her mother or nanny fussing about "sitting up straight" and "being ladylike," but she looks as if she simply wants to escape all this elegance. The little girl seems to have had enough of being prim and proper, much like Mary Cassatt in her own youth.

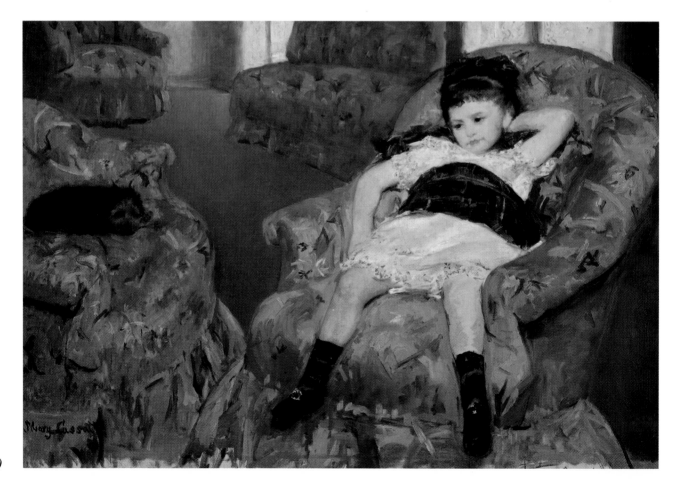

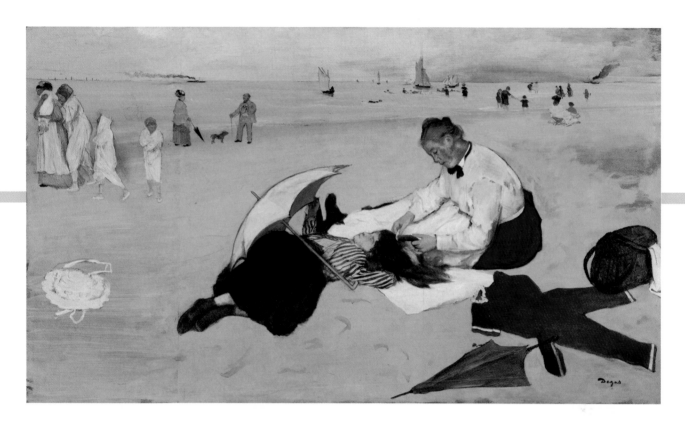

Beach Scene

EDGAR DEGAS

YOU PROBABLY KNOW THE WORK OF Degas because his pictures of ballet dancers are often featured on cards and calendars. But his work is much richer than just those pictures.

Degas was interested in painting the customs of wealthy Parisians in the 19th century. He wasn't all that interested in nature—people were his favorite subjects. In fact, looking at Degas' work can tell you as much about fashionable 19th-century Paris as reading a book on the topic.

This picture, however, is of a day out. The child is going to swim—her bathing suit, lying flat on the sand next to her nanny, awaits her. How awful it must have been to put on a scratchy woolen swimsuit that covered you up completely and became heavy when it was wet. But

that was the fashion of the time. And I wouldn't want to get sand in lace-up boots like those she is wearing!

The light in the picture is murky and bleak. A storm is certainly brewing, for the two children are gripping their towels for dear life on the top left of the picture. It is extraordinary how covered up everyone is on this beach, even with the cold. Farther off are a man and a woman with a small dog. They look as though they are walking in the city—she with her hat and parasol, he in a suit. You never see people dressed like this on the beach today. Life has certainly become more comfortable and free for children since this little girl went for her outing to the beach.

The Rabbi and His Grandchild, 1913

MARK GERTLER

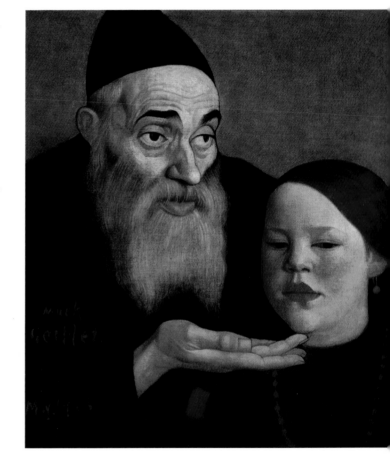

FAMILY RELATIONSHIPS ARE NOT ALWAYS about parents and children. In some families, children see a lot of their grandparents, who may have more time to stop and talk than parents who are busy working. And it is not unusual for several generations of a family to live together in the same home. But it is not a relationship that is often pictured in the art of the past.

Mark Gertler has painted a rabbi with his grandchild. Look at the gentle way he taps his granddaughter's chin. There is no doubt about his loving feelings for her.

The son of refugees from Poland, Gertler was born in the East End of London. He studied with a rabbi in 1897 before training at London's Slade School of Art. The community Gertler grew up in held its rabbi in high esteem because he taught people the beliefs and philosophy of the Jewish faith and schooled them in ancient Hebrew. Mark Gertler, in his own words, admired the "magnificent men (with their) long silver beards and curls, looking like princes in their rags and praying shawls, swaying, bending, moaning, groaning at their prayer."

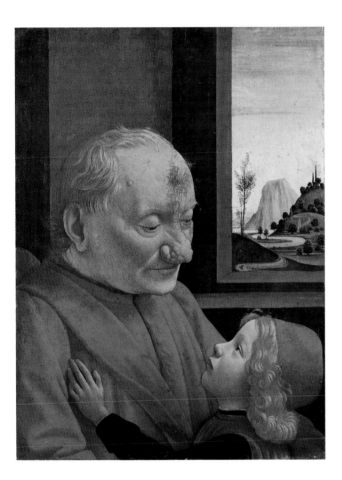

Grandfather and Grandson
DOMENICO GHIRLANDAIO

THERE ARE ALMOST 500 YEARS between these two paintings, but they are about the same thing—love. In this picture by Ghirlandaio, the little 15th-century boy is reaching up to his grandfather for a hug. He doesn't mind that his poor grandfather's nose is covered in an ugly rash of warts, then an incurable skin disease. This is his grandfather, and he loves him. Clearly the feeling is mutual, for the old man looks down on the little fellow with infinite tenderness.

Look at the road that we see out of the window. It snakes its way out of the painting toward the blue mountain, but it seems to have no end. With this technique, Ghirlandaio encourages us to think about infinity and love in the same thought.

Domenico Ghirlandaio was a famous artist and teacher in Renaissance Italy. He supervised a painting workshop with his brother, Davide, in the center of Florence, where they specialized in producing huge religious paintings for churches. Ghirlandaio also taught many young painters who came to study with him—including Michelangelo.

Dream of a Sunday Afternoon in the Alameda, 1947-8 (details)

DIEGO RIVERA

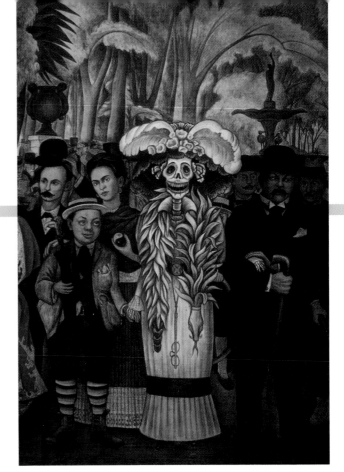

DIEGO RIVERA WAS A BIG, JOLLY ARTIST who enjoyed life to the fullest. A Mexican, he was very proud of his magnificent country. The hot sun-baked colors of Mexico are the colors that he loved to use in his art. Many Mexican people dress in the reddest reds, the hottest pinks, and the bluest blues, and they often paint their buildings in equally bright colors!

This painting, a long mural painted directly on a wall, is about Rivera's childhood memories of the Alameda Park, the main park in Mexico City. On Sundays in Rivera's time, everyone dressed up to show off their new and fine clothes. Rivera put everyone in his painting—pickpockets, street urchins, peasants, soldiers, heroes of the Mexican Revolution, and even the conquistadors, who were Spanish conquerors of Mexico in the 15th century. The painting is a panorama of Mexican history as well as an autobiography of the artist.

In the detail above, you can see a self-portrait of the artist as a fat little boy with a frog in his jacket pocket. He is holding

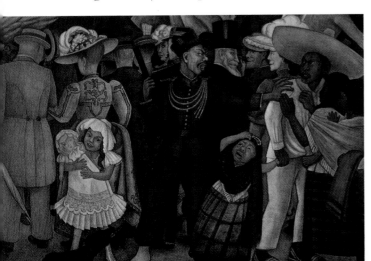

the hand of a skeleton, who is grinning and dressed up in her Sunday best. She is meant to be funny, although this probably seems strange to you. Mexicans have an attitude toward death that is different from most others—they laugh at death to make life more joyful. The Mexicans think of people like flowers—they grow, they bloom, and they die.

The second detail, from another part of the mural, shows a pale-skinned little girl dressed in white lace and carrying a very large and expensive doll. Next to her, a little native Mexican girl is dragged roughly away by her peasant father—a soldier's heavy hand on his shoulder. Diego Rivera's sympathies always lay with the poor native people of his country. Here he is pointing out that the descendant of Mexico's early conquerors, has everything, while the peasant child has nothing—not even the right to enjoy her day out.

My Grandparents, My Parents and I, 1936

FRIDA KAHLO

IF YOU LOOK AT THE RIVERA PAINTING, YOU will see a beautiful woman standing behind him. This is a portrait of Diego Rivera's wife, Frida Kahlo. When she was alive, she lived under the enormous shadow of her artist husband, but now her work is recognized and appreciated throughout the world. Kahlo and Rivera lived together in a bright blue house at Coyoacan in Mexico City. It was the same house in which she was born.

Frida had a difficult life. As a teenager, she had a terrible accident which left her partially crippled and in much pain. But Frida was magnificently brave and funny. When she was older, she had to stay in bed most of the time, wearing a plaster cast from her neck to her waist. She turned it into a colored waistcoat by painting wild flowers and crazy patterns all over it. In fact, many of her pictures were painted while in bed.

Because of her accident, Frida Kahlo couldn't have children of her own, and so she became a "fairy godmother" to other people's youngsters. She adored children and was very interested in childhood, especially her own.

In *My Grandparents, My Parents and I,*

Frida painted herself as a two-year-old. She is standing in the courtyard of the blue house in front of her Mexican-Indian mother and her German father. Her grandparents are floating in the sky. A red ribbon connects her to her family. She shows us her whole history, from the moment she came into being in the bottom left of the picture, through the stage of lying curled up safely in her mother's womb, to being a little girl.

She encompassed her whole family and her love for them in this one "family tree" painting. She seems to say, "This is me. This is where I came from, and I am very proud of it."

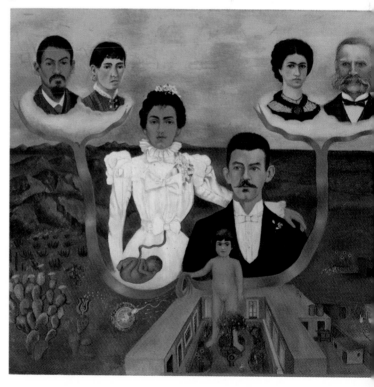

VI. OUTINGS

The Painter's Daughters Chasing a Butterfly, c. 1756

THOMAS GAINSBOROUGH

MARY AND MARGARET GAINSBOROUGH were adored by their father, one of England's most important painters. Although they are wearing what appear to be very elegant clothes, they seem to be enjoying the freedom of a run in the garden, away from the formalities of adult company.

The girls are pictured chasing a butterfly, which is disappearing out of the picture at the left. Gainsborough's choices in positioning these subjects may seem unusual, but he has created a lively feeling of movement as our eyes follow the butterfly out of the painting. We can imagine that in a few moments, the girls will follow it and the garden will be empty.

Butterflies had been used as symbols of hope in the 15th and 16th centuries, but here the painter has used a butterfly to express the undisturbed freedom of childhood. Gainsborough has caught his lovely, graceful daughters in the years of their childhood, and his pride in them is plain for us to see.

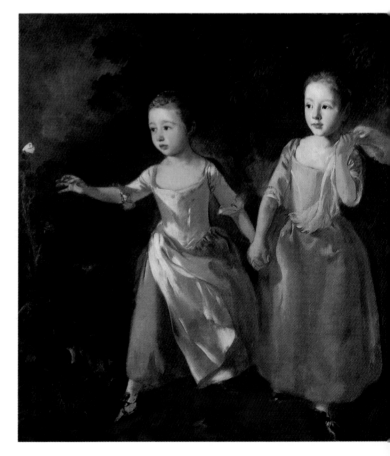

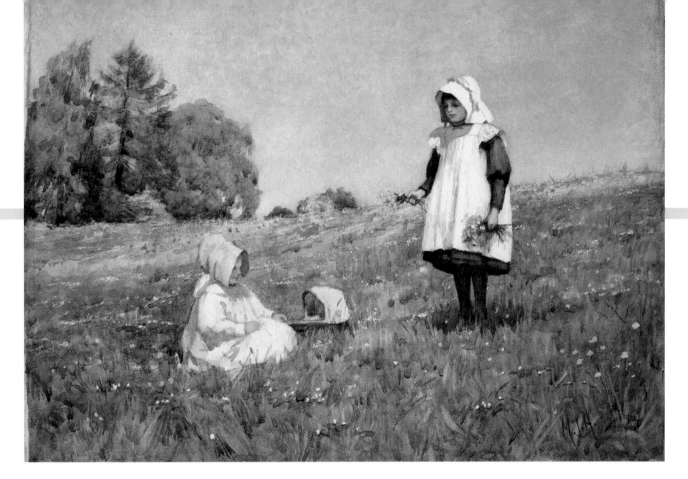

Picking Buttercups
MINNIE JANE HARDMAN

GROWN-UPS OFTEN THINK OF childhood as a wonderfully innocent time in their lives when someone else—usually their parents—took all the responsibility and did all the worrying. British Victorians, in particular, were sentimental about this time of life. This painting by Minnie Jane Hardman depicts the carefree days of a country childhood. The little girls, dressed in their frilly summer dresses and bonnets, haven't a care in the world. The sky is blue, the field is full of wildflowers, and all is well in the world.

Like Gainsborough's daughters (opposite), these little girls are enjoying themselves in the open air—but they are country children, much more at home in the woods and flower-filled meadows than the more sedate children in white stockings and beautiful silk dresses of a century earlier.

Paintings of this type were very popular in the 19th century because they cheered people. Victorian cities were dirty, sooty, and foggy. People used coal as fuel in their fireplaces, which polluted the air and caused the famous "pea-soup" fogs of London. This painting is attractive because it acts as a magic carpet—whisking us back to an age of innocent rural enjoyment.

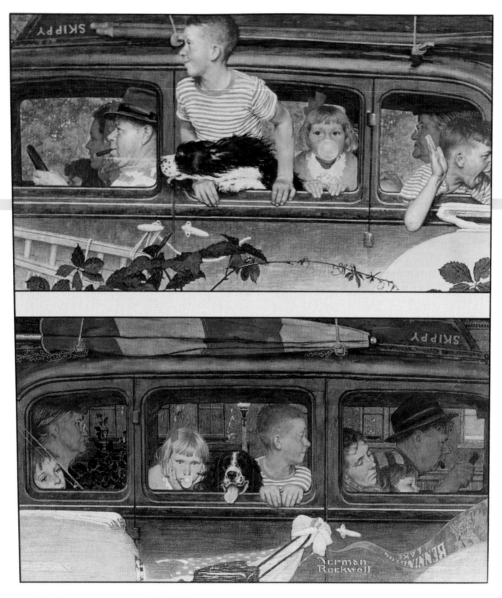

Going and Coming, 1947

NORMAN ROCKWELL

NORMAN ROCKWELL IS A MUCH-LOVED American artist, famous for his entertaining covers for *The Saturday Evening Post*. He painted over 300 covers depicting what he called "sincere, honest, homespun" Americans. This picture of four children, Grandma, the family dog, cigar-smoking Dad, and kerchiefed Mom, is a beautiful example of his work. And Rockwell's pictures always tell a story.

Rockwell, who lived in New England, painted this family going to and coming from a day spent boating on Bennington Lake in Vermont. "Skippy" is the name of the boat, which you see on top of the car.

In the top picture, *Going,* the family is excited, and their posture is alert and full of energy. Expectations are high; the day is going to be great! The little girl's bubble is huge, and her ribbon is fresh. Everyone looks optimistic, even the dog. Dad is smiling. His hat is neatly centered on his combed hair. Mom's eyes are on the road. Grandma looks resigned.

In the picture called *Coming,* everyone is tired and disheveled. The bubble gum is less impressive, the ribbon lies flat, the dog is panting with thirst, Dad is tired and hunched over the wheel, and Mom is asleep. Grandma is still resigned.

What a day!

VII. THE WAY WE LOOK

Mummy Portrait of a Boy
EGYPTIAN, ROMAN PERIOD, A.D. 150

CLOSE IN AGE TO THE FELLOW IN *The Torn Hat* by Sully (page 40), this portrait was found resting inside the bandages of an Egyptian mummy of a twelve-year-old boy. It is painted in encaustic, a method in which the paint is mixed with melted wax.

Unlike many Egyptian portraits, which are very stiff and formal, this piece looks as if it were painted using a live model. The unknown artist has made the boy look so alive and friendly. The young face is intelligent and open. The only secret is the reason for his tragically early death.

Princess Isabella de Medici, 1542
ANGELO BRONZINO

BRONZINO CAME FROM FLORENCE, ITALY, and, like Holbein (page 28), was privileged to be a painter to a royal court. Bronzino's master was not a king but a powerful duke, Cosimo I de Medici, first Duke of Tuscany.

His little picture of a Medici princess is formal like many of the other commissioned portraits that we've seen, but it is special in its own way. The little girl looks almost modern. She stares out at us across 450 years as though time doesn't exist. Her gaze is directly into our eyes. Her nickname was Bia, and she was obviously a great favorite with everyone at court.

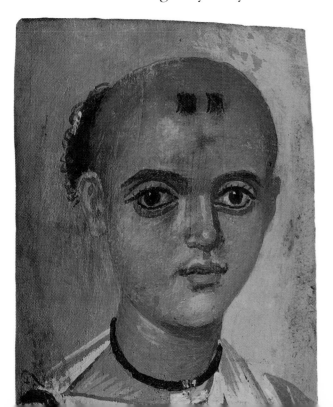

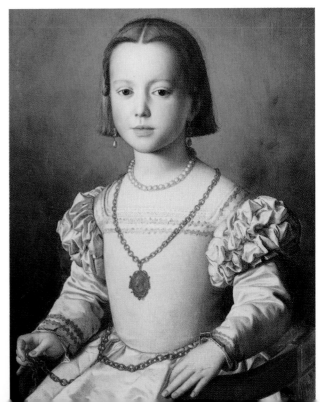

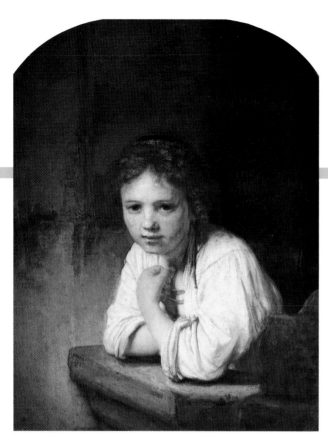

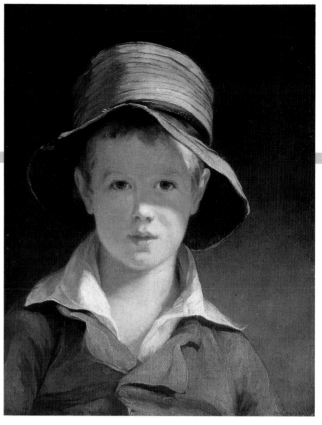

Portrait of a Young Girl Leaning on a Window Sill
REMBRANDT VAN RIJN

The Torn Hat, 1820
THOMAS SULLY

REMBRANDT'S YOUNG GIRL SHOWS US YET
another treatment of children in this
earlier time. She looks much more
friendly than Bronzino's princess and a
little shy as well. She looks as though
she's just come to the window for a
moment to tell Rembrandt to come in for
dinner. She probably worked in the artist's
house in Amsterdam.

Rembrandt suffered great tragedy and
hardship in his life. He lost three of his
children in infancy and his wife Saskia.
His beloved son, Titus, supported and
cared for his father until his own death in
1668. Rembrandt's many self-portraits
became a kind of diary—charting the way
that the hardships of his life both aged
and changed him over the years.

HAVE YOU EVER HAD A PIECE OF
clothing that you liked so much
you couldn't bear to throw it
away? I think this nineteenth century
American boy is wearing his favorite straw
hat, with its broken brim, to feed the
chickens or to go fishing with his father.

Thomas Sully painted many portraits of
Americans during the early years
of the country's independence. He was
one of a group of talented painters
anxious to establish a school of painting
that was not influenced by European
ideas. He embodied this sense of a new
nation emerging most perfectly in one of
his finest and best-loved paintings,
Washington Crossing the Delaware.

VIII. PAINTING THE PICTURE

First Steps, 1943
PABLO PICASSO

Pablo Picasso had his own children when he painted this picture, but they each lived with their mothers. Judging from this painting, I think you can see that he missed them. He certainly felt very tender toward the toddler in this picture, although he uses jagged shapes to define the child's clothes. The style he uses is called "cubism," which he developed with his friend Georges Braque in 1906.

Cubism is a way of trying to see around the corners of things. We know that when we look at something from the front, we can't see the back. Picasso thought that artists should be free to break this rule. A cubist picture is a bit like a painting behind broken glass. All of the forms are smashed into new and surprising shapes which make us think about the world in new and surprising ways.

Look at the way the baby's left foot bends back upon itself. Isn't that how it really *feels* when you walk, rather than the way it looks. Cubism allows Picasso to do this. Picasso has also squashed the mother's head to curve around the baby's. This may not look realistic, but the curve adds to the sense of protectiveness of the mother as her baby makes her first steps.

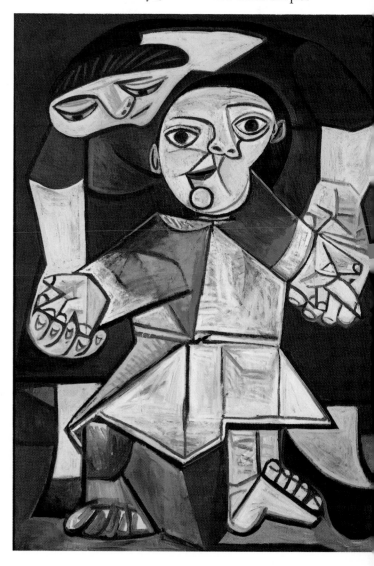

Mme. Roulin and Her Baby, 1888

VINCENT VAN GOGH

My Mother Reading to Frank, 1989

CELIA PAUL

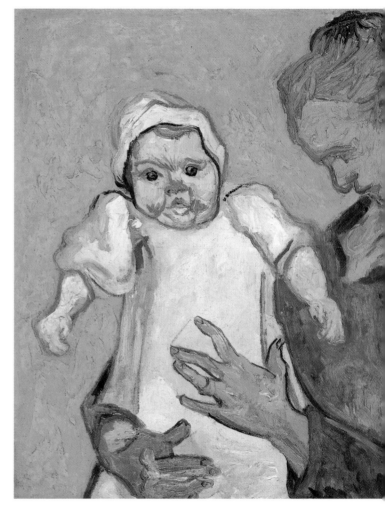

THESE TWO PAINTINGS ARE SEPARATED IN time by a hundred years, but they are rendered in a similar way. Both artists used paint almost as if it were clay and applied it with their fingers and palette knives, as well as brushes. This is their technique.

Both were in their thirties when these pictures were created, but Celia Paul is alive and well and hard at work in London today. Vincent van Gogh died under tragic circumstances in 1890, two years after he finished this picture.

Both artists came from religious families. Celia Paul was born in India and is the daughter of a bishop. Vincent van Gogh was the son of a Dutch pastor. Their upbringings may have influenced the strong, religious elements in their work.

Van Gogh was passionately interested in religion as a young man. He tried unsuccessfully to become a priest before he took up painting. He worked as a missionary in the poverty-stricken district of the Borinage, in Belgium, but was terribly unpopular with his parishioners. These humble, simple people found him too extreme in his religious views. His eccentricity frightened the coal mining families in his parish, and he was dismissed in 1880. Van Gogh became

terribly confused about his belief in God and life, and he suffered from mental illness. He ended his life himself, in a state of terrible depression. But during his short, creative life, when he was feeling well, he painted glorious pictures, showing both joy and sorrow.

These two pictures have similar textures. They are painted in such thick paint that if you get up close to them, you can see the paint literally sticking out from the canvas. Neither artist uses just a paintbrush to lay the paint on the canvas. They scoop the paint up with any means available, including their fingers! A knife instead of a brush makes the paint look like butter and gives it a satisfying, thick creaminess. In the van Gogh, you can see swirls of thick paint on the baby Marcelle's pudgy arms. She was the three-month-old daughter of his friendly postman.

Celia Paul's son, Frank, is sitting on his grandmother's knee. He is five years old in this picture. Look at his left hand. Can you see that it is just a mass of oil paint all whizzing off in different directions? The artist uses paint so expressively that there is no doubt that we are looking at his hand. The painting has a wonderful logic of its own.

It is very hard to do this type of painting well. It's part of a technique called "scumbling." The artist puts layer upon layer of paint on the picture, using the oil paint almost like clay. The paint then dries with a broken-up look, and you can see the colors piled on top of each other.

The way an artist actually puts paint on the paper or canvas actually tells a personal story. The "touch" of an artist is almost like a fingerprint. It is absolutely unique to him or her, whether it's the emotional, expressionist style of painting such as van Gogh's and Celia Paul's, or the cool, mathematical approach using dots of color like Seurat (page 45).

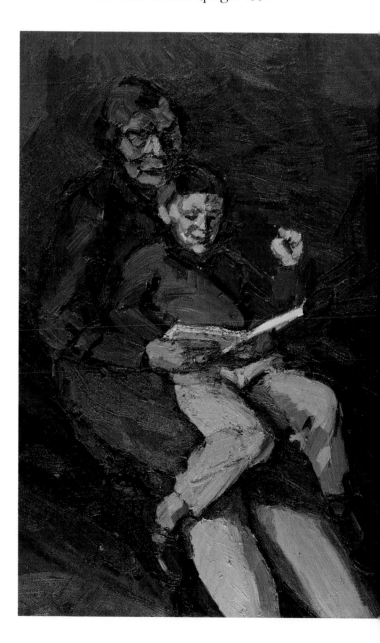

Liberty Blake in a Kimono, 1971

PETER BLAKE

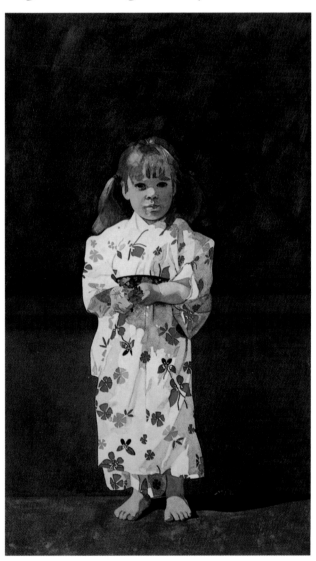

THIS IS A PORTRAIT OF THE ARTIST'S three-year-old daughter, Juliet Liberty Blake. I like it very much because I know just how difficult it is to paint your own children. Imagine having to model for your mother or father—they forget how boring it is for you. It's difficult not to fidget constantly and ask, "How much longer?" I sometimes even have to pay my own children to model!

One solution to this problem is to work from photographs. Like Norman Rockwell (page 38), Peter Blake uses photographs to help him in his work. Sometimes he copies them almost exactly, and sometimes he changes them to suit the purpose of his painting. Sometimes he uses them simply to jog his memory.

What makes the picture so appealing is the clothing the child is wearing. They are special clothes from another culture—but this is not a formal portrait. This silky kimono is Japanese and covered with pretty patterns. Blake concentrates as much on her clothes as he does on her little round face squinting in the bright sunlight. The flowers on the kimono seem to jump off the cloth into the flower which she holds in her hand.

The flowery pattern relates to the garden setting in which she stands. The background is very loosely painted in contrast to the detail of her dress. The sweet baby nature of the little girl's face makes interesting harmonies with the sharply-painted details of the cloth. Once again, the painting shows an artist's love for his child.

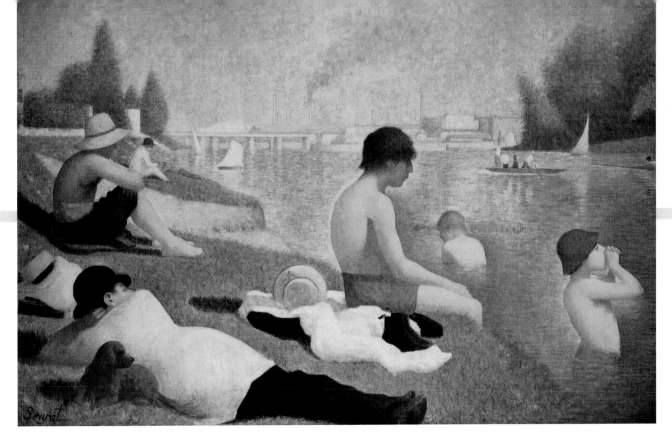

Bathers, 1884

GEORGES SEURAT

THE 19TH CENTURY WAS A TIME OF GREAT innovation and invention in both art and science. Impressionist artists like Monet (page 21) experimented with painting light. Scientists were interested in light too, and they developed theories explaining how we see color. Frenchman Georges Seurat was influenced by the color theories of the scientist Chevreul, and he used them in his painting.

Chevreul believed that color could be divided into two categories. You know that the first category, primary colors, includes red, yellow, and blue.

You have also been taught that the secondary colors are orange (made from mixing red and yellow), green (made from mixing yellow and blue), and violet (made from mixing red and blue), therefore making six colors out of three.

Chevreul's mathematical theory delighted Seurat. Chevreul stated that if you put a primary color next to a secondary color that *didn't* contain it, you would get a brilliant contrast. He called these "complementary" colors. So if you put an orange next to a blue, or a green next to a red, or a violet next to a yellow, the colors will really buzz. Try it the next time you are painting and see what happens. Seurat did in every picture.

Look carefully at the grass in this picture. Is it really as green as it looks? No. It has a lot of complementary red in it. Look at the river. Is it really blue? No, again. It's actually full of dots of orange.

But the picture isn't merely an exercise in color theory, it's also a painting about laziness. The boy on the riverbank looks bored, and the man in city clothes and a hat must be very hot. Seurat wants us to notice that the city is not very far away. As the factory in the background belches out smoke, you can almost feel the heat along this sunny patch of river near Paris.

Umbrellas in the Rain, 1899
MAURICE BRAZIL PRENDERGAST

T HIS IS A PAINTING OF VENICE IN THE rain. Venice is said to be one of the most magical cities in the world. It almost floats on a shallow lagoon, a bit like a swamp, and is made up of many tiny islands connected by bridges like the *Porta della Paglia* in the picture.

The architecture of Venice is wonderful too. Much of it looks like delicately piped frosting on a wedding cake. Tourists flock to Venice, making it a very crowded place. This painting shows us that, even a hundred years ago, you could scarcely move through the masses.

Prendergast was an American artist who studied art in Europe. He was very excited by the fresh, new approach to painting he first saw when in Europe.

By painting Venice in the rain, he has done two clever things. First, the splashy, watercolor technique that he's used lends itself to describing the puddles of rain on the ground and the reflections of the children. Prendergast has painted Venice, the city of water, with water itself. At least everything looks very wet!

Second, he wanted to convey the impression of great crowds of people, and he wanted to do so without having to paint every little detail. So the brilliantly painted umbrellas give us the impression of great numbers of people.

Some of the children don't seem to mind not having umbrellas—as long as there are puddles to jump in! These figures were painted in more detail, an ingenious visual trick that the artist used to coax our wandering eyes in the direction he intended them to follow.

We never forget that we are looking at a picture of children in this painting, but we're also made subtly aware of the "pearl of the Adriatic," glorious Venice.

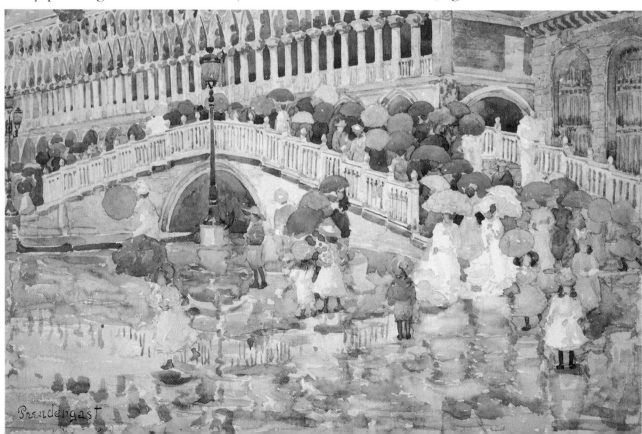

IX. THE PAINTINGS